HOW TO DRAW
FANTASY

STEP-BY-STEP
DRAWING BOOK FOR KIDS

TEACHING BASICS
AND BEYOND

Paul Könye

WELCOME TO

Planet DRAW

All **Planet Draw** books are designed to upgrade your skills, inspire your imagination, and help you master popular drawing subject matter – from simple cartoon characters to serious sketches.

Never dull and always fun, we'll tickle the funny bone with twisted 'toons and mega mashups.

**From kids' stuff to cool stuff…
from Okay to YES WAY!
Take your drawings to another Planet!**

CONTENTS

ABOUT THE AUTHOR

Hi, my name's Paul Könye. I'm excited to introduce you to **Planet Draw**, especially created to share my love of drawing with a new generation of budding artists.

With my partner Kate Ashforth, I have authored a number of best-selling 'How to Draw' titles over the past decade – one of which sold over 2 million copies!

I'm also an accomplished storyboard artist and have created illustrations for countless books in Australia and New Zealand.

Visit **www.planetdraw.com** to see some of my work!

WHY PLANET DRAW?

- ☑ Master popular and classic subject matter

- ☑ Clear step-by-step instructions with super-helpful notations

- ☑ Graduated learning from simple to complex – but always fun!

- ☑ An insider's view – "Coming up with ideas for a character"

- ☑ Plenty of inspiration and tips to create your own designs

- ☑ Thinking outside the square – get wacky and a bit twisted

Let's get started!

Find out more at
www.planetdraw.com

CARTOON CORNER

Time to concentrate on simple shapes and forms and not get carried away with too much detail. This small bite out of the cartoon cosmos is all about doing the basics right and having fun.

BABY DRAGON

LEVEL
Easy

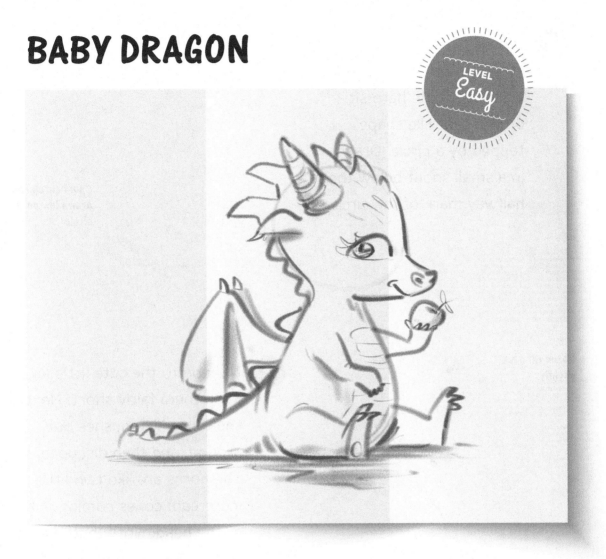

This cute little bundle of joy is the apple of its mother's eye. Butter wouldn't melt in her mouth. But with fire-breathing lessons just around the corner, this pint-sized flying lizard is set to become the fiery overlord of her domain.

Feared or befriended – it's your choice.

1 It couldn't be an easier first step. On top of the baseline where our cute hero sits, draw a tear-like shape topped by a circle. Draw in a small snout below the halfway mark of the circle.

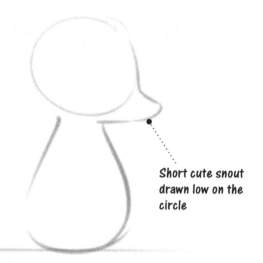

Short cute snout drawn low on the circle

Horns tilt back slightly

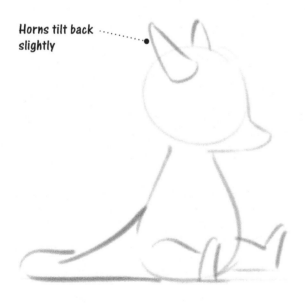

2 Now on to the cute little legs. Keep them fairly short. Next the tail, which pushes out, around, and then disappears. The horns are like two little ice-cream cones coming out of the head. Note that one sits behind the curve of the head.

START DRAWING NOW!
GO TO PRACTICE PAGES
CHAPTER 7

STEPS 3 & 4

3 Draw the first wing as shown and observe how it forms folds. Indicate where the first ridges on the head begin and then proceed with the tiny arms. Propped up on one of the dragon's paws is a small apple. It's very important to position the eye correctly. In this case, it's below the halfway point of the head and close to the snout.

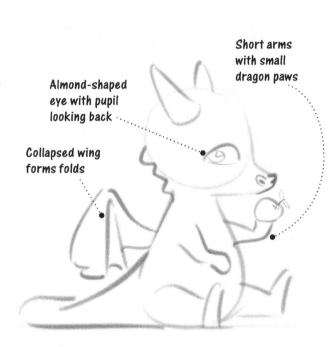

Short arms with small dragon paws

Almond-shaped eye with pupil looking back

Collapsed wing forms folds

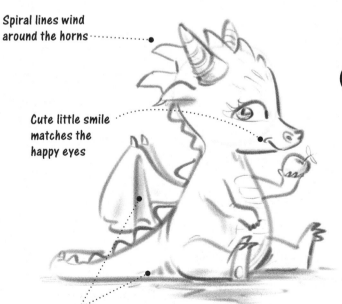

Spiral lines wind around the horns

Cute little smile matches the happy eyes

Shading helps accentuate the forms and adds texture to the skin

4 Having done the hard work of setting up all the essential forms, you can move on to adding detail and strengthening your line work. More ridges, scales or, if it takes your fancy, add a pattern.

YOUNG UNICORN

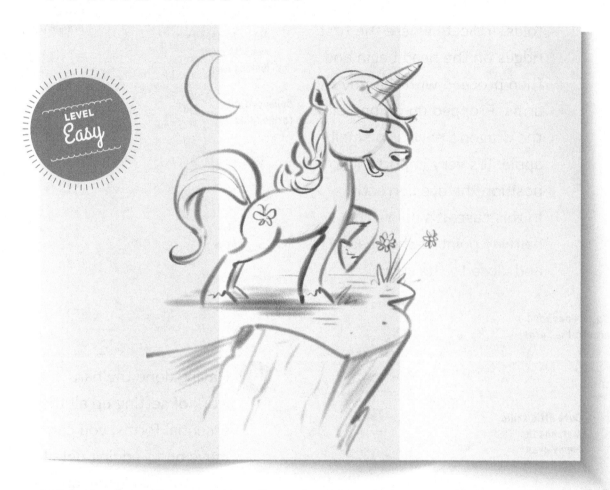

With the boundless energy of youth, this unicorn is itching to leap over gorges and touch the moon. But patience will have to be the order of the day as he hasn't got his flying license just yet.

When fully formed with outstretched wings, this enchanting prince of the meadows will dash and dive between the glades, and no doubt have the princesses of the land swooning at his style.

STEPS 1 & 2

1 Start with an oval shape sitting high above a baseline. Draw two S-like lines descending from the oval. The one on the left follows the dip and curve of the spine. The other wave line is more subtle, tilting inwards and nearly reaching the ground.

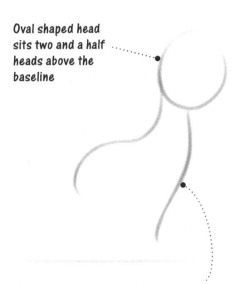

Oval shaped head sits two and a half heads above the baseline

Front line descends from the chest and down to the front right leg

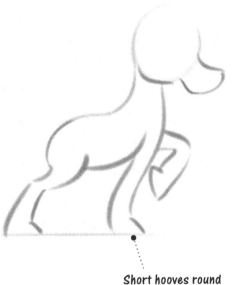

Short hooves round off the curvy legs

2 Draw the snout low on the right-hand side of the oval. Don't draw it too big – this is a young unicorn after all. Three of the legs follow with curves that echo each other, providing a slight forward lean.

START DRAWING NOW!
GO TO PRACTICE PAGES
CHAPTER 7

3 Flowing long and tousled hair follow. Don't make it too neat and tidy. Lock in the right ear and all-important horn on a nice 45-degree angle.

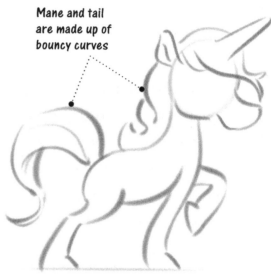

Mane and tail are made up of bouncy curves

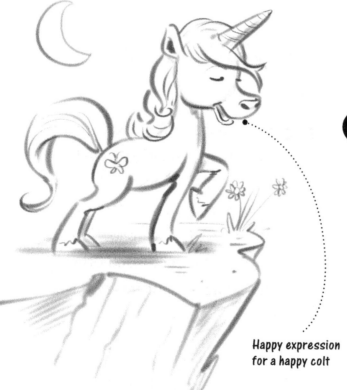

Happy expression for a happy colt

4 The final step is an opportunity to place your unicorn in an environment. Details like the cliff's edge, moon, and flowers are all you need to capture this young colt, eager to take flight, but not quite ready to do so.

EVIL SORCERER

LEVEL *Medium*

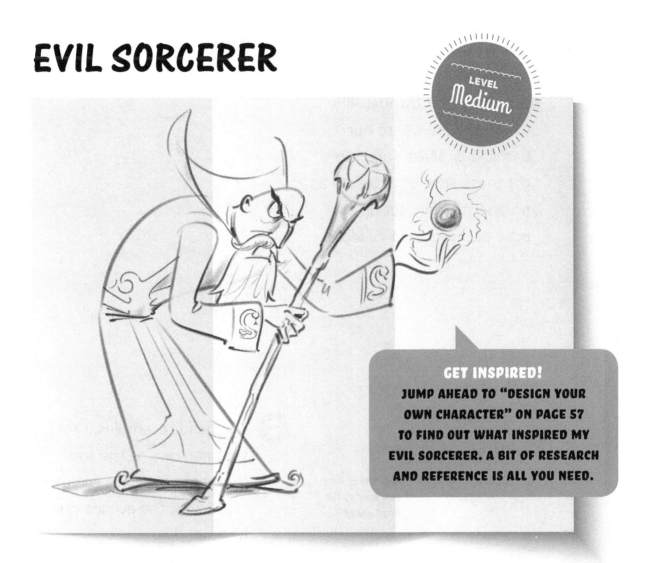

GET INSPIRED!
JUMP AHEAD TO "DESIGN YOUR OWN CHARACTER" ON PAGE 57 TO FIND OUT WHAT INSPIRED MY EVIL SORCERER. A BIT OF RESEARCH AND REFERENCE IS ALL YOU NEED.

Tired of wearing the badge of evil sorcerer, this cunning conjurer wants a reputation fit for one of such awe-inspiring magic. How about Fantasmo or the Lightning King? Age may have wearied him somewhat, but with the collective wisdom and knowledge of 300 years, the "special" one has some special plans for his pesky adversaries. Let's hope you're up to dodging his fantastic fireballs.

1 The first lines that are drawn are those of the hunched-over back and through-line to the ground where our baseline is. Make sure you get these lines as accurate as possible as they set up the pose of our crazed evildoer.

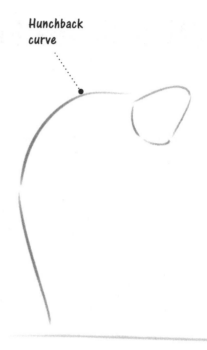

Hunchback curve

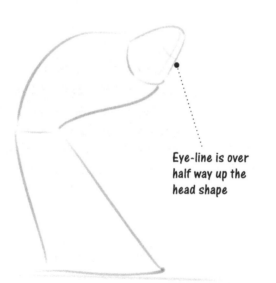

Eye-line is over half way up the head shape

2 The head resembles a rock that narrows at the top. Be sure to indicate the face cross with the eyeline quite high up.

STEPS 3 & 4

3 This next step is made up of three basic shapes. The two largest forms are part of the sorcerer's robe. The bottom half leans back and the top half curves forward. You could call it an old man's stoop. The head is a stubby, cone-like shape. Observe how the bottom of that shape sits on the chest line.

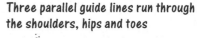

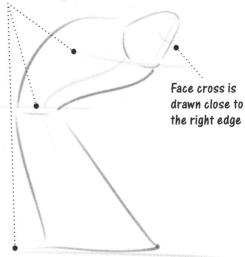

Three parallel guide lines run through the shoulders, hips and toes

Face cross is drawn close to the right edge

A staff is drawn on a lean, with a ball-like shape on top

A long nose descends from the brow and sits on top of the beard

Little flourishes like the curl of the slippers are a nice character detail

4 Following the face cross that you've already drawn, indicate the furrowed brow and egg-like eye. Use another oval-like shape to indicate the beard and then move on to the arms. These are an extension of the robe, so have them fan out a bit before they reach the position of the hands. Little turned-up slippers peek out from under the robe.

5 Add as much detail as you want in this the final step. I've crafted his long staff out of ancient timber and topped it with a large jewel. Expressive hands, gritted teeth, and a fireball ready to be flung finish the character off perfectly.

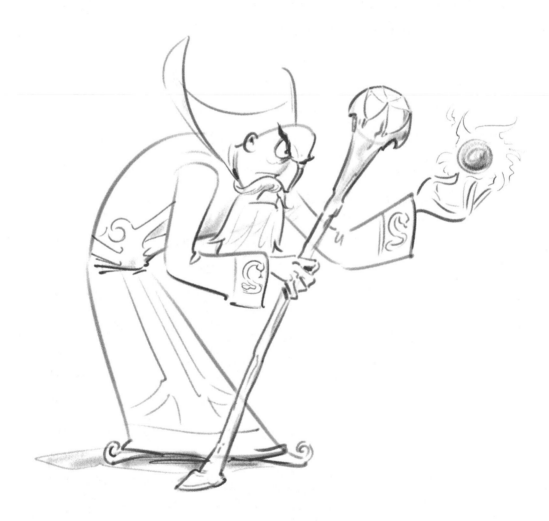

MERMAID

LEVEL
Medium

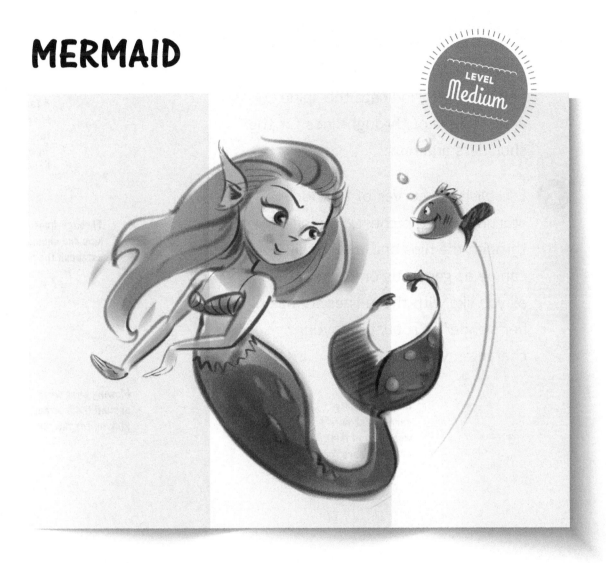

Giving up her mermaid life for the love of a prince is not for this unique aquatic creature – she's having too much fun. With a smile from ear to ear, she glides underneath the sun. The stunning ocean wilderness is her playground. With the heart of an explorer and so many fishy friends to keep her company, the world really is her oyster.

1 Draw a circle for the skull. Add some gentle curves to indicate the cheek and jaw. Next, indicate the spine and a couple of through-lines for the shoulders and hips.

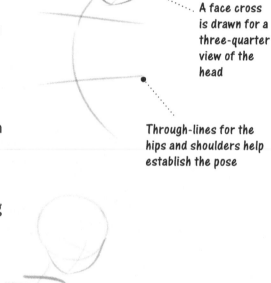

A face cross is drawn for a three-quarter view of the head

Through-lines for the hips and shoulders help establish the pose

2 Establish the curves of the body starting with the chest, moving down through the hips and to the tail. You can be as generous or conservative as you like with those lines to making her slender or robust. It's your character, your choice.

Flowing lines wrap around the hips and kick up for the tail

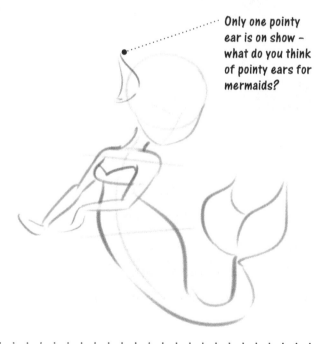

Only one pointy ear is on show – what do you think of pointy ears for mermaids?

3 Arms and fins follow. Make them as expressive as you want. I've shown a dance move of sorts, but you could give her a karate chop move if you like. Two leaf-like shapes make up the fins.

STEPS 4 & 5

4 Long flowing locks are next. Imagine them swaying in the waters around her. Draw a pair of lovely almond-shaped eyes, which are better than walnut-shaped eyes. We're just about done.

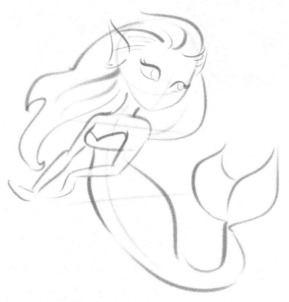

Little fishy friend having a dance with the mermaid

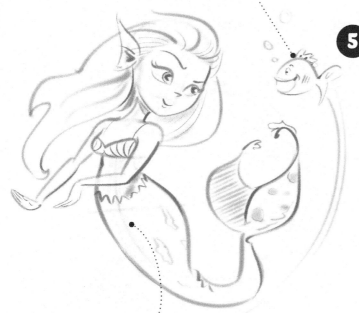

Pattern details help bring the character to life

5 A shell-designed bikini top begins the costume detail. Scales, water droplets, and/or circles can be used as a pattern on her tail. Strengthen the line work and add a bit of shading for depth. Give her a happy little swimming companion and you're all done.

IN FOCUS

The detective in all of us wants to collect as many clues as possible to solve the riddles of drawing supremacy. Look no further than the pages ahead, where we will delve in delicious detail and tackle topics of key importance such as facial expressions and action poses.

FACIAL EXPRESSIONS

What great fantasy tale isn't full of high drama and emotion – be it hero or villain, monster or maiden? Let your readers in on your characters' feelings with great facial expressions. I encourage you to mix it up, from a naughty goblin or a blubbering orc.

Faces are extremely elastic and each individual expression pushes, stretches, or contracts different parts of the face. To highlight this, I thought I'd grab a well-honored selection of creatures/characters from the fantasy universe.

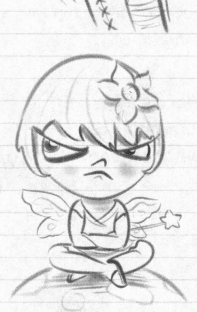

21

In one drawing, I'll showcase an expression we've probably come to expect from them. Then conversely, I'll highlight an expression that shows a different side to our character.

Some of your favorite cartoons on YouTube and TV are made up of the very simplest of creations. They don't adhere to anatomically correct proportions and are built from a few simple shapes. Therefore, as artists we have full license to exaggerate and go over the top with our expressions.

Here's a few examples of what I mean.

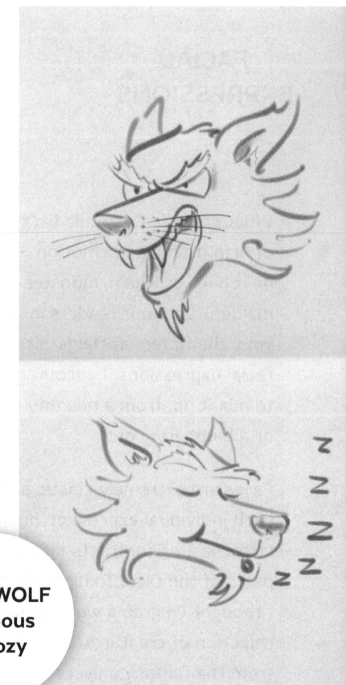

WEREWOLF
ravenous
or dozy

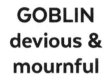

GOBLIN
devious & mournful

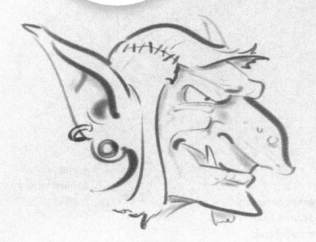

suggested face shape for angry appearance

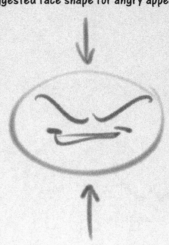

face shape stretched out for sad and mournful look

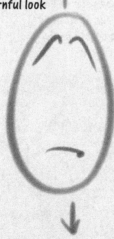

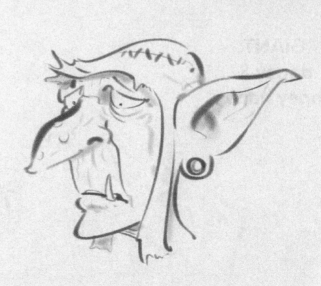

ORC
death stare & cry baby

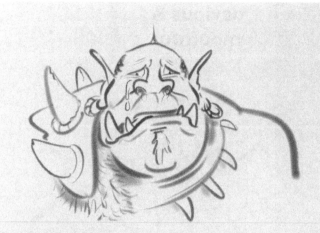

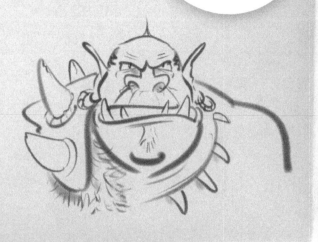

creases between eyebrows help sorrowful look

eyelids curve upwards when tearful

GIANT
dopey & dopey happy

nice relaxed line loops up at ends to create smile →

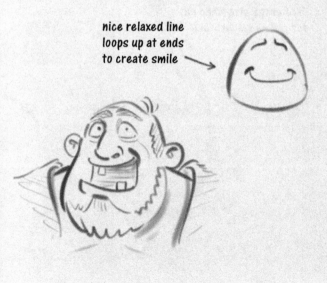

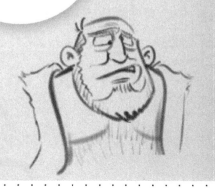

ELVEN KING
regal & goofy

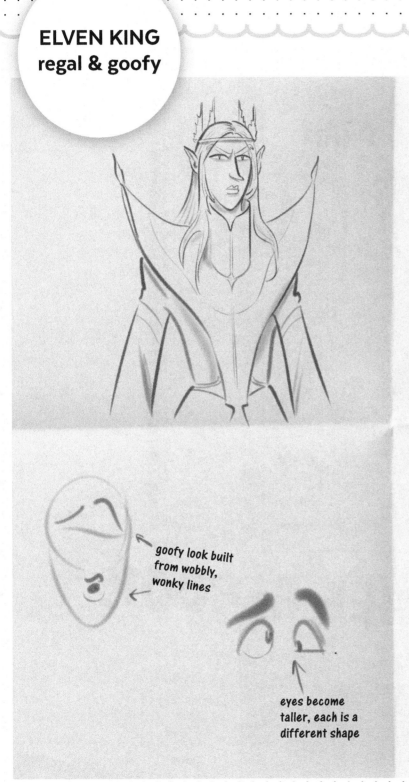

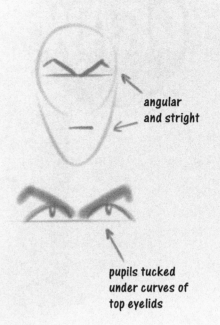

angular and stright

pupils tucked under curves of top eyelids

goofy look built from wobbly, wonky lines

eyes become taller, each is a different shape

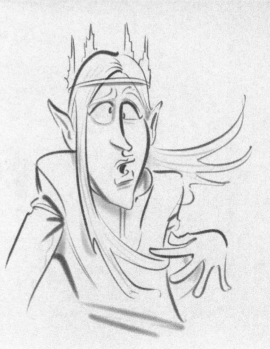

SERIOUSLY SENSATIONAL

Are you up for the challenge? Talented artists and aspiring sketchers will find these seriously sensational subjects a tricky test of your drawing wits. Sound advice is on its way for generating ideas and character design.

RE-INVENTING THE WIZARD

When you think of a wizard, you think of an old and gray hairy thing, about 400 years old. He would sport a ridiculously oversized hat with a gown down to the feet, which must be there to hide some very wrinkly, veiny legs. You can draw such a fellow if you want to stay true to the mythology, but wouldn't it be nice to try something different?

If you start drawing ideas down like I did, you can end up with a chap like this. He may be more youthful, but baby face here is too cartoony for my liking. And what's with the clothes? He looks like a medieval priest.

YOUNG WIZARD

LEVEL
Hard

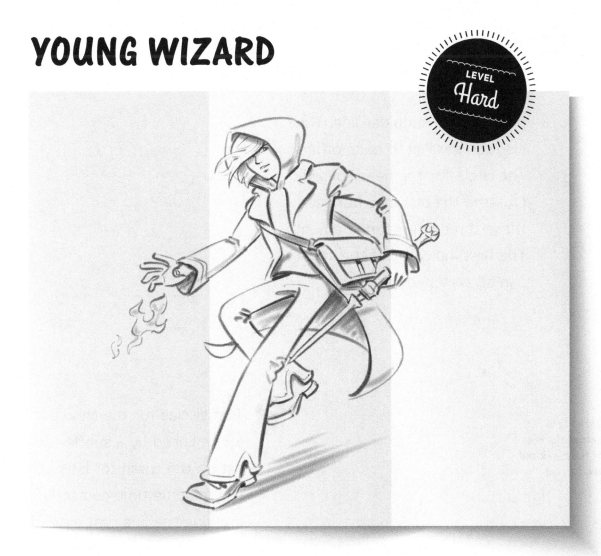

So with contemporary cool in mind and a slight nod to manga, I settled on this design. Our young wizard is in fashionable, incognito attire, sleuthing around the urban neighborhood with his wand at the ready. The hoodie and long fringe of hair sweep across his face. Carrying a bag of what? We don't know. Probably just a collection of chocolate and other confectionary to keep him going through the night on his adventures.

1 The first step seems simple enough, but it is important to get the angles correct of both the baseline and shoulder line. They also run parallel to each other. The circle for the head follows. Observe the distance between those three important elements. The first indicator of the spine can be sketched in next.

Spend time getting the line of the cheek and jaw correct

2 Two circles for the shoulder joints linked by a subtle curve set up the torso for later. Then spend some time correctly drawing the line that extends from the top of the skull (circle in this case) down through the cheekbone to the jaw. Make it too big and our young wizard might look too old. Too small and he may look too young.

STEPS 3 & 4

3 Draw the torso and head well above the angled baseline to allow for the long legs still to come. Note the angle of the line through the shoulders. This is important to get the pose right. The head tilts forward and sits just above his right shoulder. Lightly draw in the face cross.

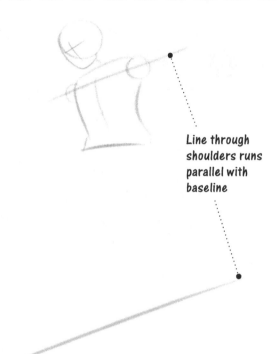

Line through shoulders runs parallel with baseline

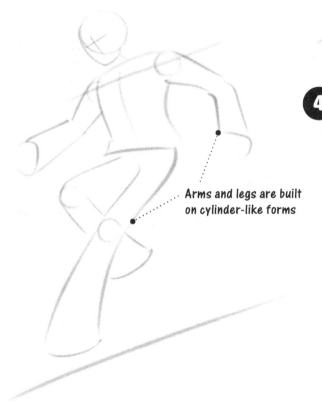

Arms and legs are built on cylinder-like forms

4 Continue with your foundation drawing, sketching the arms and legs. Line up his left knee with an imaginary line running down vertically from the head. This step is all about achieving a balanced pose. That can be difficult, particularly with an action figure. You'll know things are awry if the figure looks like it's about to fall over.

5 Having finished the foundation drawing, let's move on to the more refined drawing, starting with his flowing trench coat and hood. A couple of big collars are added next.

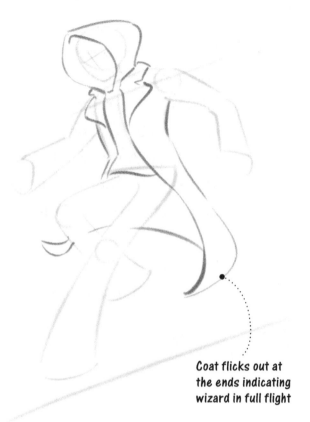

Coat flicks out at the ends indicating wizard in full flight

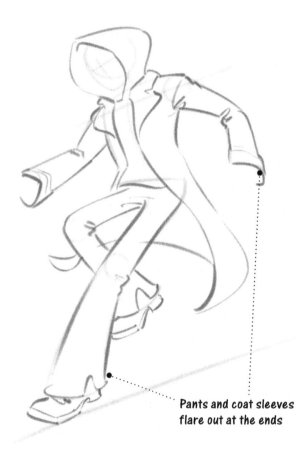

6 Fill out the rest of his outfit including his pants, shoes, and coat arms. Observe where creases form at the bends of the elbows and knees. Thick-soled shoes can follow.

Pants and coat sleeves flare out at the ends

STEPS 7 & 8

7 A subtle sweeping line will indicate his high cheekbone. Follow that with his long floppy fringe, which will end up covering much of his right eye. I've gone for a more ornate wand than usual while keeping his shoulder bag fairly simple. Feel free to change up these designs if you have other ideas. The fingers of his right hands are flared out for throwing a fireball.

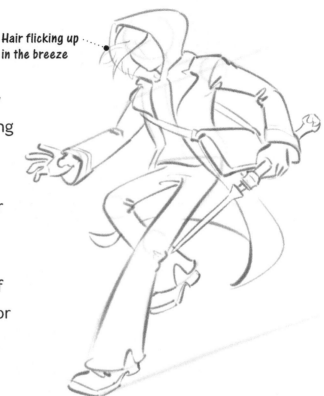

Hair flicking up in the breeze

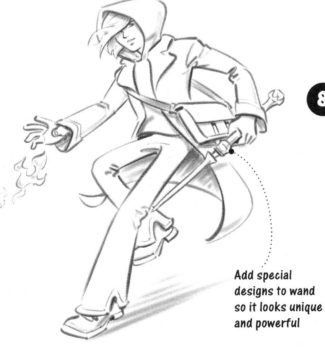

Add special designs to wand so it looks unique and powerful

8 Draw his eyes, nose, and mouth with small curvy lines. They shouldn't be too exaggerated or large. This is a discreet kid of character. A minimal use of gray tone and dark accents should help lift the figure off the page and into life. Let the magic begin!

WARRIOR PRINCESS

LEVEL
Hard

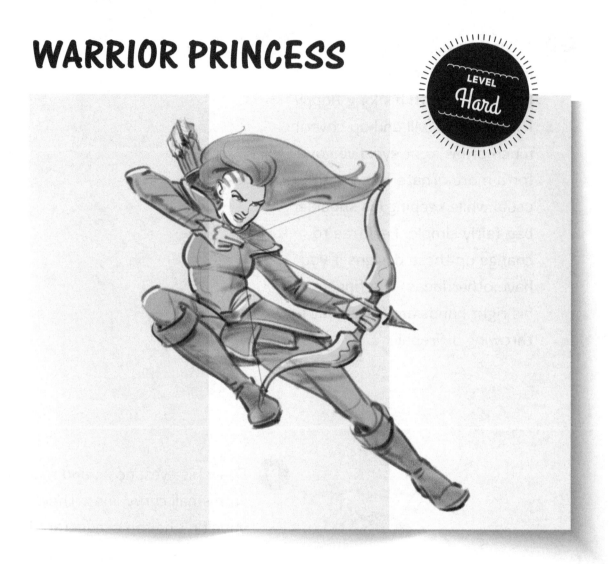

Many characters in the world of fantasy live pretty incredible lives, whether they're embarking on a quest, running from danger, or casting their spells. When we set about this drawing quest to bring them to life, we really want them to leap off the page. Dynamic poses are the key.

EARLY DRAWING

When I started out creating studies for my warrior princess, they were rather static. Given I wanted my character to be an action superstar, a simple standing pose wasn't going to cut it. My second effort was better. My heroine was leaping into action and primed for battle. The flourishes of flowing hair and twisted skirt suggested some movement. But it still wasn't enough.

FINAL DESIGN

My last effort, and the prelude to my final character design, was right on the money. The angles of the limbs were sharp and acute, and there was a strong dynamic line running down from the head through the spine, and out through the left leg. With confidence in my new design, I settled for a cool hairstyle and adapted a traditional outfit into something more modern. The epic bow and arrow adornment seemed to be the perfect accompaniment for my streamlined heroine. Now on to the drawing steps!

X

Ok

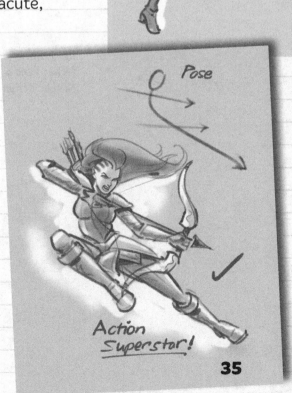

Pose

✓

Action Superstar!

35

1 It's always nervous starting off a drawing of this complexity. Spend time on the first step and you'll go a long way to success. There are two through-lines you can draw: the first one through the shoulders and the second one through the hips. Observe the angles they are on. A curved spine line follows and extends through what is going to be the legs.

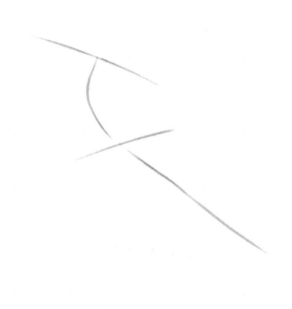

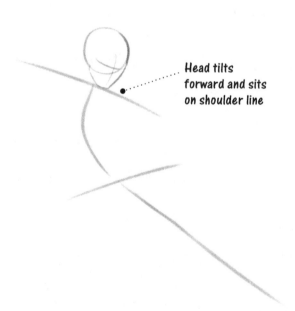

Head tilts forward and sits on shoulder line

2 Draw a circle for the skull just above the shoulder line then move onto the cheek and jaw line. It should sit just on the shoulder line. The face cross can follow once they are both accurately drawn. All three elements tilt forward. This is to set up the pose for the head, which is leaning forward.

STEP 3

3 It's super critical to get the pose correct from the start. First target those important through-lines that run through the shoulders and hips. Observe the angle they're on. There's a flow/gesture line that sets up the whole action. It reflects the curve of the spine and flows through to the left foot. Even though we're drawing a complex human form, break it down into individual shapes stating with the torso and head. Draw lightly.

Three vital flow lines set up the pose: shoulders, hips, and spine

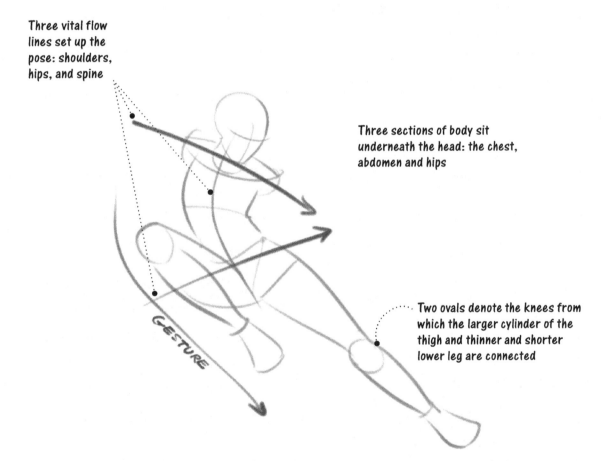

Three sections of body sit underneath the head: the chest, abdomen and hips

GESTURE

Two ovals denote the knees from which the larger cylinder of the thigh and thinner and shorter lower leg are connected

4 Step two is a continuation of the build in step 1. More cylinder-like shapes form the arms, and it's the first time we see the bow. I'm happy with the tusk-like shapes that make its design but feel free to draw it any way you like.

Bow shape can be your own design

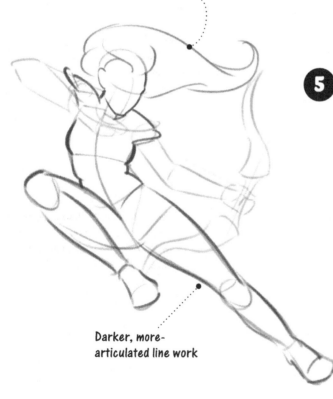

Hair adds to the feeling of movement

5 Our first two steps have provided the groundwork for the more refined drawing. That can start now with the warrior princess's wild hair flicking out to the right, and the beginning of her costume. Notice how the outline here is a complex chain of small curves.

Darker, more-articulated line work

STEPS 6 & 7

6 The full leather outfit, from arms to feet, is drawn in next. Notice the petal-like shapes that descend from her hips adding to the flare of the costume. Arms, hands, and boots follow. Take your time and follow the lines of the under drawing.

Head-to-toe leather outfit completed

Draw an expression of controlled aggression using the face cross as your guide

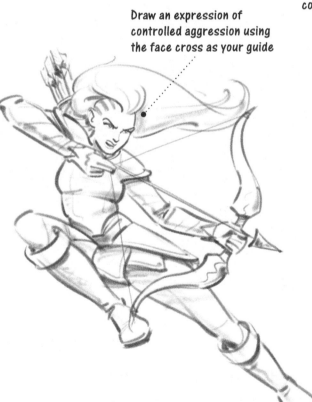

7 We've caught our warrior princess mid-action. Her expression should be one of focused aggression. Her eyes are locked on her target. She's in the moment, primed, and in full flight. Apply some shading and further costume detail and you're done.

FOR MORE TIPS AND TRICKS, CHECK OUT PRACTICE PAGES ON P.76

EXTRA BITS

I was really happy with the hairstyle I chose for my warrior character. It was suitably edgy with the shaved sides. I had whipped up a wildness that suited a warrior who was just as at home in the forest as she was in the provincial villages.

TIP •
USING REFERENCE MATERIAL

The pages of these compact books don't allow for deep exploration of anatomy or variations on action poses. I recommend you obtain reference books that will help with your knowledge in these areas. If you're intending to become a character designer or comic book artist, they will be invaluable to your development.

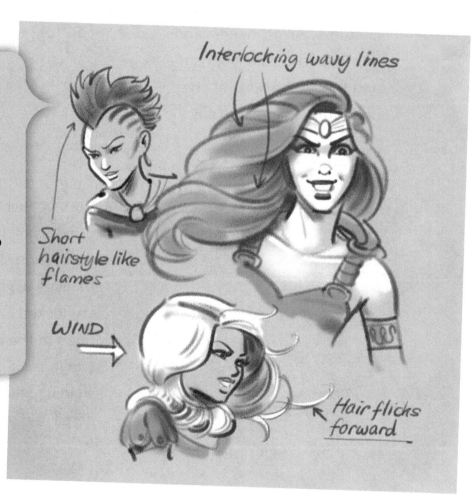

Interlocking wavy lines

Short hairstyle like flames

WIND

Hair flicks forward

Play around with hairstyles in your studies and try to match the personality of your fantasy character. Here are some variations.

MEGA MASHUP

Take two innocent subjects and throw them into a blender to see what might come out. After you've had fun noodling around with these creations, get into the lab and whip up a few of your own. What about a dancing dragon or a fairy frog? Bonus points for triple and quadruple mashups ...

PUNK PRINCESS - MASHUP

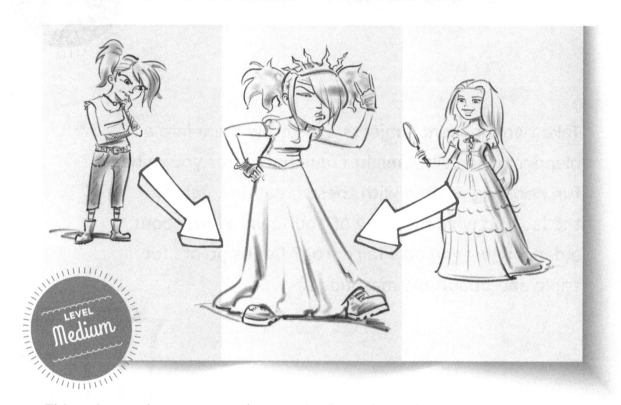

LEVEL
Medium

This princess has a pumped-up attitude and a radical take on pretty royal attire. We've created a marvelous mashup melding fantasy and tradition with a two-finger salute. The lack of respect and angsty attitude might appear ill directed at first. But channeled into her love affair for raucous guitars and outrageous solos, our dark princess appears set to rock any event.

She's happy to wear the long flowing gown (in black of course), but leave those impractical heels behind. I'm stepping out with some big bad boots that talk TUFF like the chords screeching from my guitar.

STEPS 1–3

1 There are four guidelines to draw. Start with the baseline then move up to the angled through-lines of the knees and hips and finally the shoulders. Above that shoulder line, draw a circle which is to be the foundation of the head.

2 Lightly sketch the outline of the body next.

Upper back tilts down

3 Next, the outline of the body becomes more articulated. Allow for the folds to be drawn in later steps.

4 Draw the head shape tilted forward with matching face cross. Start indicating the folds of the dress and then the waistband, which sits on the hip guideline.

Several folds on different angles

Arms and guitar neck form a triangle

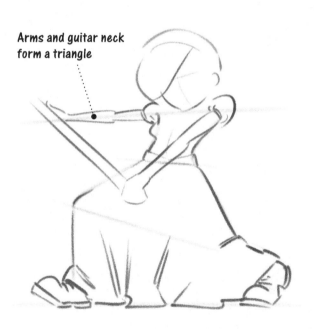

5 Slim, straight arms jut out from under the puffy shoulders of the dress, almost forming a neat triangle with the guitar neck. Draw her oversized boots.

START DRAWING NOW!
GO TO PRACTICE PAGES
CHAPTER 7

STEPS 6 & 7

6 Continue with the guitar, before working through our little punk princess's spiky hairdo and tiara. A cool, aloof expression is key to nailing the attitude of our royal upstart.

Feel free to choose your own guitar design

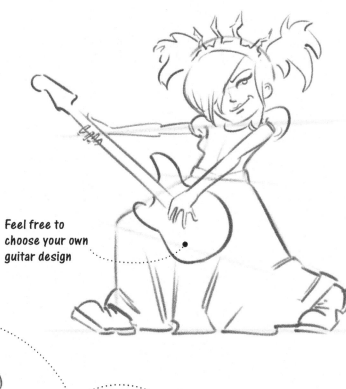

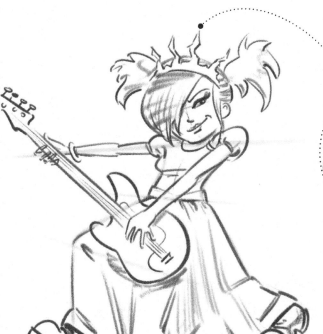

Like a crown of thorns, rather than a bejeweled tiara, this headdress is in tune with the flame-like shapes of her pigtails.

7 Put more detail into the dress, guitar, and hair and you've completed your virtuoso drawing of a virtuoso performer.

ROBOT KNIGHT

LEVEL
Medium

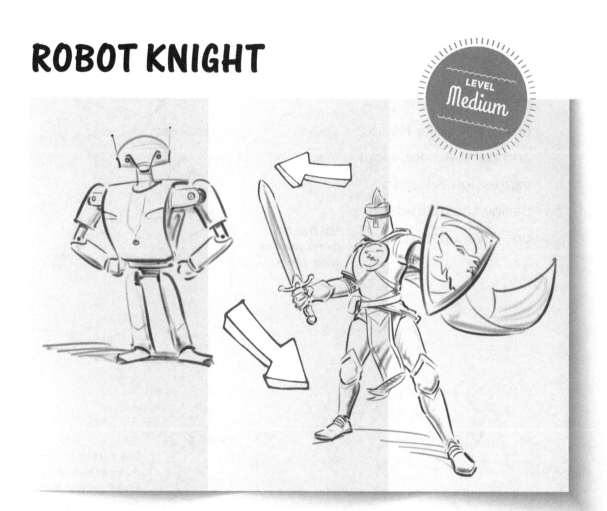

What do you get when you combine a robot and a knight? Fantasy collides head on with science fiction.

The past and the future combine to create a knight without a heart. But what he lacks in human attributes he makes up for in machine muscle. He peers from under his Frankenstein's monster brow, his vision laser sharp and his shoulders broad and battle ready. Pity the fools who lock horns with this knight. His reign at the top is assured.

STEPS **1** & **2**

1 To get this pose correct from the get-go, draw the baseline and lines through the hips and shoulders on the correct angle. Draw the flared leg shapes and torso curves next.

Guidelines set the blueprint for your pose – start with the simplest of shapes

Short curved lines form shoulder and pelvis areas

2 Having done your blueprint, you can now start to build the form of the robot knight. Start with the hips and shoulders, then add the shoes. He has very broad shoulders and a big barrel chest that pushes out. Try to emphasize this with curvy lines.

3 Draw the cup shapes that concertina out from under the shoulder joint. Develop his chest plate, then move on to his legs. I've broken the leg up with what looks like some big shin guards. It makes the legs more interesting and robot-like.

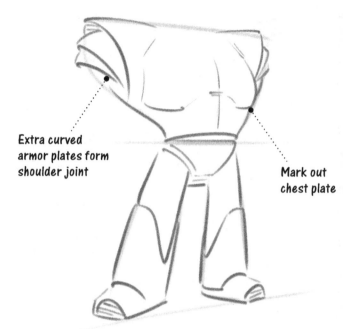

Extra curved armor plates form shoulder joint

Mark out chest plate

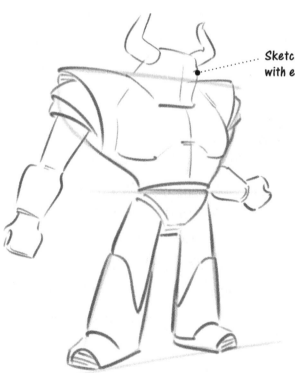

Sketch block-like head with eye line high up

4 Sketch the head and horn shapes. We're going for a Frankenstein-like head here. Put in the face cross next and draw in the cylinder-like arms.

FINAL STEP

5 I'd spend a bit of time on the face, really nutting out that "don't mess with me" expression. Holes for the eyes and nose add to the darkness.

And what would a robot knight be without his weapons? There's no hard-and-fast rule here. I've given him a sword and shield, but you could have him holding a mechanical spear with his left hand and a ball and chain in his right.

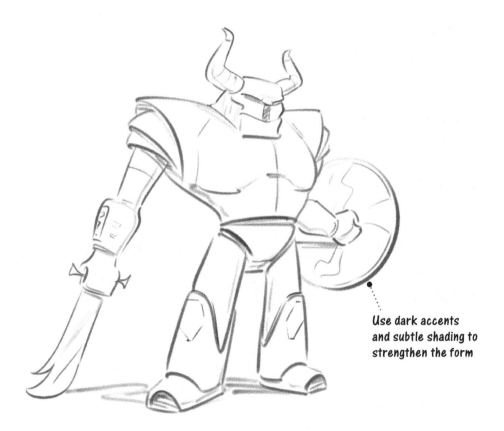

Use dark accents and subtle shading to strengthen the form

CREATE YOUR OWN DESIGNS

HAVE FUN!

Start creating your own variations on the robot knight. Use the first step of my design and work up your own character, playing with brand-new head types, choice of costume, and weapons.

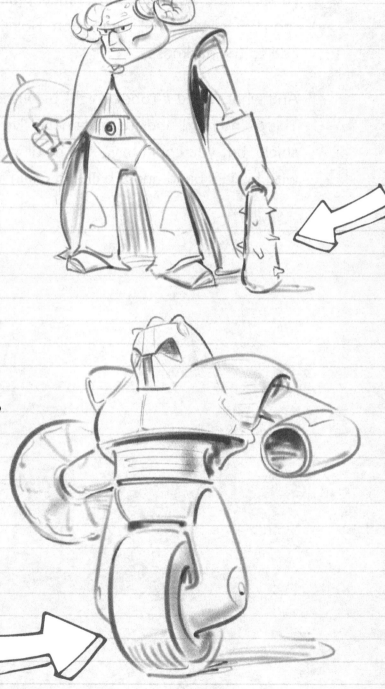

TWISTED 'TOON

Let's go crazy with subjects close to our hearts!
Take something traditional and poke a little fun at it.
You've seen, you've drawn, you've conquered.

Now it's time to party and do the twist.
Silly sausages, nonsensical nincompoops,
and crazy coconuts need only apply.

FAIRY WITH ATTITUDE

LEVEL *Medium*

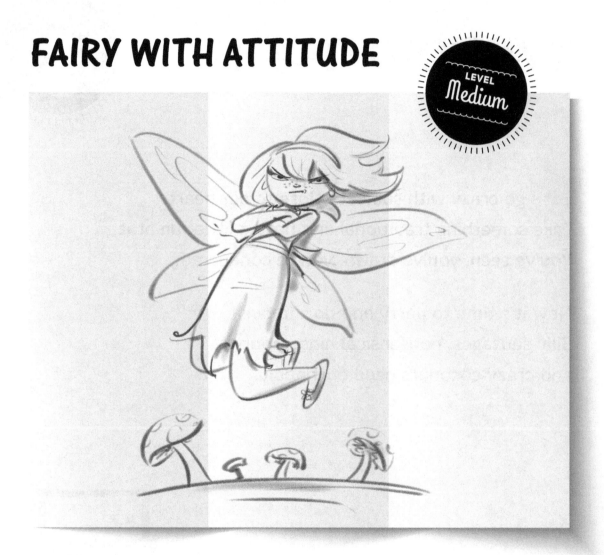

This is another twist on a classic. This time the bright and bubbly fairy has been replaced with an upstart who's a bit tired of hanging back at home with the stinky mushrooms. Mum and Dad aren't going to be pleased. But what's new?

STEPS 1–3

1 Start by drawing a balloon shape for the head. Don't draw it too dark because later we are going to draw her hair and face over the top. The tooth-like shape of the body follows. Notice that it's tilted to the right. This sets up the leaning-back pose of our angry young fairy.

Squat oval shape for head

2 A tooth-like shape forms the fairy's torso, on top of which sits a circular form for the head. Note the angle (about 30 degrees) on which all the shapes, including the long legs, are bound.

Very long legs stretch down from the tooth-like shape of the torso

3 Draw the flame-like shapes of the hair that flick up to the right. The small folded arms provide the attitude. Keep them nice and high, tucked under the chin. A small pair of slippers follow.

4 Narrow almond-shaped eyes are drawn at the edges of the face. A cute button nose and mouth are very central on the face. The dress is up to you, but we still want our character to exhibit her fairy origins, so I've gone for a plant-like design.

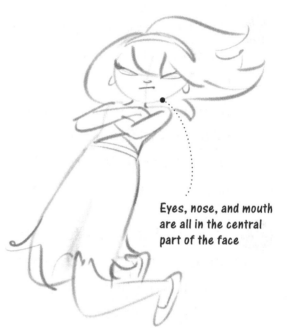

Eyes, nose, and mouth are all in the central part of the face

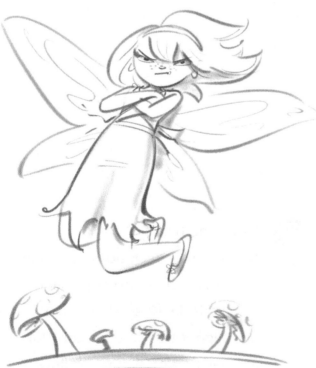

5 Add the wings and then strengthen some of your lines to add depth to the character. Your fairy with an attitude is now complete.

START DRAWING NOW!
GO TO PRACTICE PAGES
CHAPTER 7

DESIGN YOUR OWN CHARACTER

chapter **6**

I hope you've enjoyed conquering some tricky and not-so-tricky drawing challenges and, more importantly, got a taste for creating your own cool fantasy characters. As you can see, from *Cartoon corner* to *Seriously sensational*, we can all benefit from following a process:

» starting with simple shapes and forms

» using guidelines for the correct positioning of the pose and facial features

» working through a more refined outline

» finally sketching in costume and anatomical detail.

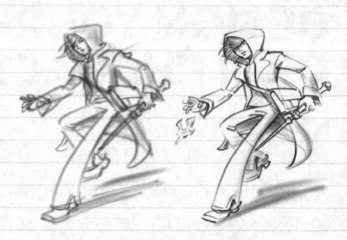

CHARACTER DESIGN STEPS

To demystify the process of character design, what better way than to lift the lid on the very process I use to create the characters for these books? With the warrior princess, I showed you how I worked through several designs to get to an optimum one. However, before any drawing begins, a little bit of groundwork is invaluable. First, nut out a basic character description. Then find a reference both for accuracy and inspiration.

These are my four surefire steps to character design supremacy!

1 Character notes

2 Reference images

3 Early sketches

4 Refined drawing

CHARACTER NOTES

If you're serious about getting the most out of your character creation, start by writing down a few character notes.

We're trying to get to the heart of their personality. Are they good, evil, or laugh-a-minute? What expression and body pose are going to show off that personality? Think about their body shape and how they carry themselves.

Costume, hairstyles, and props can be other keys to your design.

WARRIOR PRINCESS
1. Action Super Star
2. Not too girly. Strong athletic physique
3. An expression of 'she means business'
4. No dresses at all. Head to toe leather outfit
5. Edgy hairstyle

EVIL SCORCERER
1. Hunched over pose
2. Bald head and long beard
3. He is evil so must have matching expression
4. Boney hands
5. Weilding magic for his evil purposes
6. Long simple gown with minimal decoration

REFERENCE IMAGES

Cartoon villains like Jafar from the movie *Aladdin** provided the inspiration for my classic evildoer look. I discovered really good reference for sorcerers with long flowing beards and robes on the internet. Then found great inspiration for costume and props when I rewatched The *Lord of the Rings** movies.

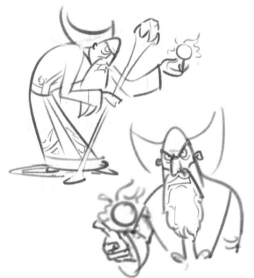

EARLY WORKING DRAWINGS

The artist is only a click away from finding very helpful references on the internet to give ideas and inspiration for their character designs. These may include photographic references or the drawings and illustrations of other artists*.

What I like to do is isolate a certain quality of a particular pic and utilize that in my own design, say, an expression or pose I like, or a cool costume. Try this yourself, and I promise you'll be well on your way to creating your own original cool design.

You've done the research. Now it's time to start drawing.

* For copyright reasons I can't show you the actual reference images I used. I can only describe them.

EARLY SKETCHES

Early sketches are your chance to work things through in your mind. They're a chance to explore different options for your character without fear of judgment. At this stage, the drawings can be rough and loose.

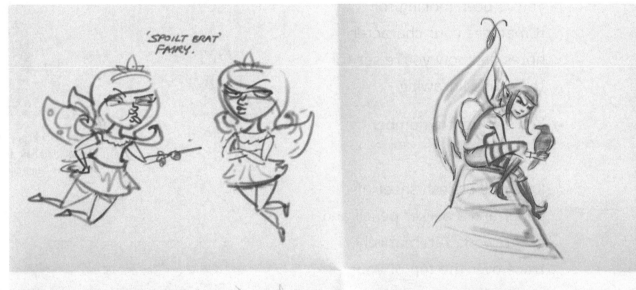

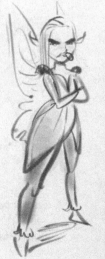

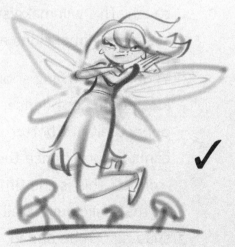

TIP •
DON'T GIVE UP!

It might take 2, 3, or 10 roughs before you nail it – but think of it as a fun process to work through. And when that one drawing aligns itself with your character notes, you'll say "That's the one!"

REFINED DRAWING

So ... you've worked up a bunch of sketches and out of the fog arrives the design you've been looking for. It matches your character notes and now you're set for the refined drawing.

You can do it a number of ways.

Just grab a fresh sheet of paper and a darker pencil and get to work. Alternatively, trace over the top of your rough. This will make sure the scale and dimensions are right.

Your final drawing should have a strength confidence. It's an opportunity to better what came before, hence the word "refine". This is the time when all that delicious detail and shading can be added.

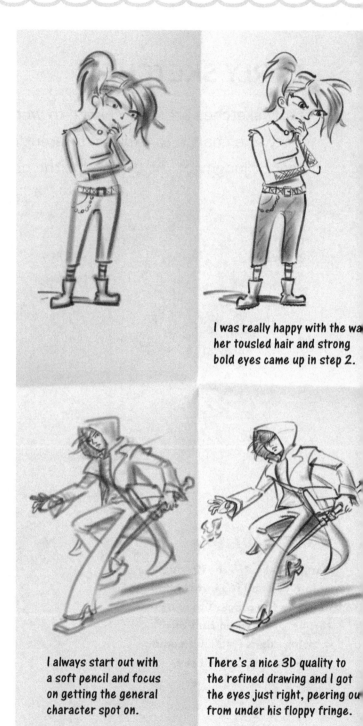

I was really happy with the wa her tousled hair and strong bold eyes came up in step 2.

I always start out with a soft pencil and focus on getting the general character spot on.

There's a nice 3D quality to the refined drawing and I got the eyes just right, peering ou from under his floppy fringe.

PRACTICE PAGES

Grab your pencil and get started! Draw <u>directly</u> onto your choice of three drawing templates. The finished drawing is shown, so you can see what to aim for.

Beginners' challenge If you're just beginning on your drawing journey, start here! The outline of the drawing has already been done so it's easy to complete the illustration, guided by some handy tips.

Next-level Want to raise your drawing game but don't want to start from scratch? This intermediate level template gives you enough to get going. The rest is up to you.

Creative blast-off The bare essentials are provided for the confident drawer who wants to push themselves to the limit and have more input into the design of their character. Inspiration is at hand with fresh design suggestions.

Dragon

Complete the subject, drawing directly onto the page.

Beginners' challenge

» Draw the almond-shaped eye low in the circle

» Onto the small arms next, with one hand holding the apple

» Complete the drawing with scales and reptilian texture

Next-level

» Legs and tail are going to give our cute little dragon her balance

» Horns are drawn like two upside down ice cream cones

» Move onto the final steps of the beginners' challenge

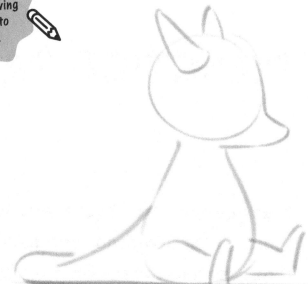

Creative blast-off

» Have as much say in your design as you like

» Change the attitude of your dragon or introduce some new props

» Why not put your dragon in an environment?

Here's what to aim for with your finished drawings!

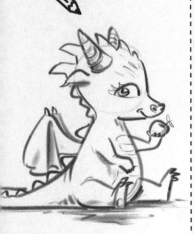

TIP · DRAWING CUTE

Cute critters, whether furry or reptilian, share some common features. They are generally more squat and round, and have larger heads in proportion to their bodies.

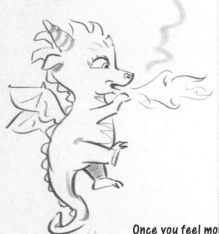

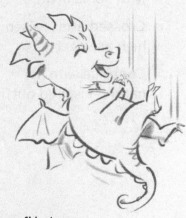

Once you feel more confident, you might like to explore some alternative character designs like these!

Fairy

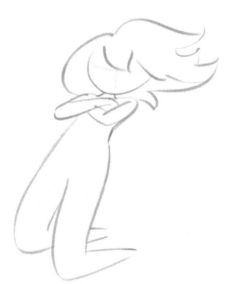

Complete the subject, drawing directly onto the page.

Beginners' challenge

» A naughty fairy has a naughty expression, so create a V-shape with the eyebrows

» A fairy needs wings and a dress – play around with the decorative elements

» She should be light on her feet, so narrow slippers of some kind will be great

Next-level

» Start drawing a wild hairdo befitting a girl with some attitude

» Crossed arms raised high are next

» Continue with her nature-inspired outfit

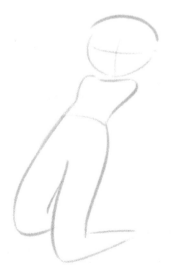

Creative blast-off

» Fairy flying, crying, or jumping for joy – change up the body language to suit your design

» From wild hair to flicking ponytail, hairstyles are lots of fun

» Friends from fairyland can come and join her

Here's what to aim for with your finished drawings!

TIP • NATURE ELEMENTS IN CLOTHING

Pattern and texture are two details I leave until the final step to enhance my drawing. I advise you do the same. With a good solid drawing done, taking in all the vital elements of shape, form, and line, you're ready for the fun part. Our fairy is a fantasy icon who lives in nature. Introducing elements from nature into her clothing and hair makes perfect sense. For example try petal- and leaf-like shapes repeated around her shoulders or neck.

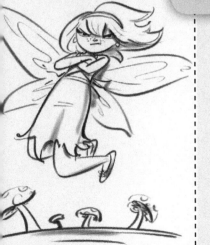

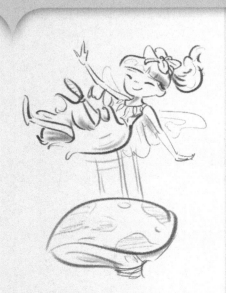

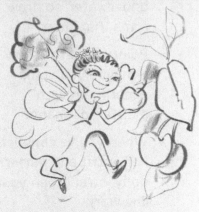

Once you feel more confident, you might like to explore some alternative character designs like these!

Mermaid

Complete the subject, drawing directly onto the page.

Beginners' challenge

» Big happy eyes set our young mermaid apart from her ocean friends

» Long flowing hair dances around her shoulders, drawn with various curved lines

» A fishy tale completes the design – have fun drawing it your way

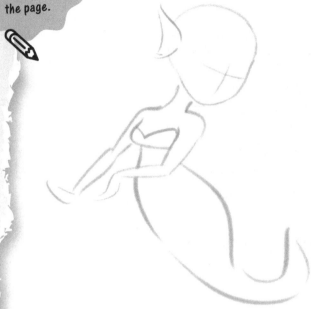

Next-level

» Our beautiful mermaid likes to dance underwater, so draw arms that show this

» Pointy ears to follow – maybe you could experiment with a different shape

» When you've completed her outfit and patterned body, strengthen your line work

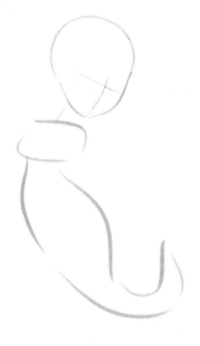

66

Creative blast-off

» Having fun in the water or being chased by a predator

» Time to create your own design with a new expression or body pose

» Who can join our ocean fairy and is it friend or foe?

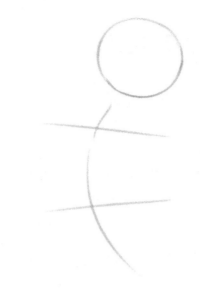

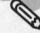

Here's what to aim for with your finished drawings!

TIP · EYE EXPRESSIONS

Whether it's an evil sorcerer or an elegant mermaid, eyes are a direct link to the character's emotional state and personality. They are so powerful that they can convey confusion, sadness, or drama – all within a few pencil strokes. Don't ignore the eyebrows. They are the dancing partners of the eyes and tilt and curve in partnership.

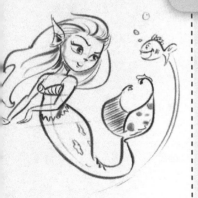

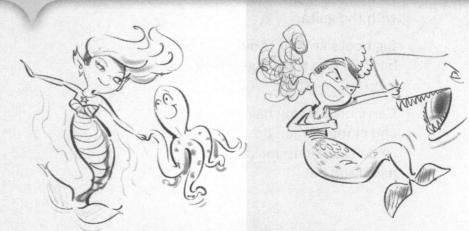

Once you feel more confident, you might like to explore some alternative character designs like these!

Punk princess

Beginners' challenge

» A rocking roll princess needs a rocking guitar – change the shape if you like

» Pigtails and tiara are drawn with flame-like shapes and help amp up the attitude

» One eye peeks out from underneath the floppy fringe and her mouth curls at the edge

Complete the subject, drawing directly onto the page.

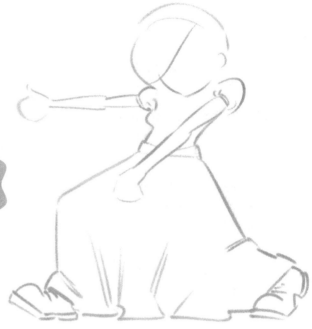

Next-level

» Arms are straight and form a triangular shape with the guitar

» Big boots are my choice but feel free to change it up

» Carry on drawing hair and clothing then do some shading to make her stand out

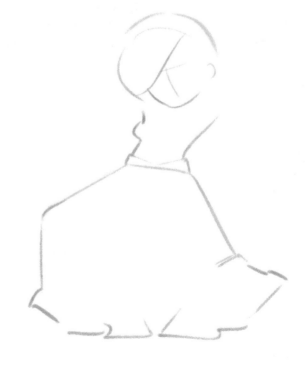

Creative blast-off

» Design your own punk princess starting with this basic pose blueprint

» She could be leaping off stage or playing in bed

» Who says she has to play guitar? Why not draw her as a singer belting out a tune?

Here's what to aim for with your finished drawings!

TIP · ATTITUDE

Every emotion and attitude can be expressed with the eyes, eyebrows, nose, and mouth. Drawing them well will go a long way to letting your viewer know your character's emotional state. For a princess with a fierce attitude, draw her eyebrows, eyes, and mouth at sharp angles to match her mood. If she's having a peaceful strum of the guitar, open those eyes up and round them off.

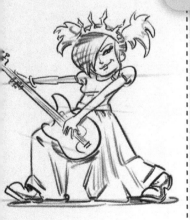

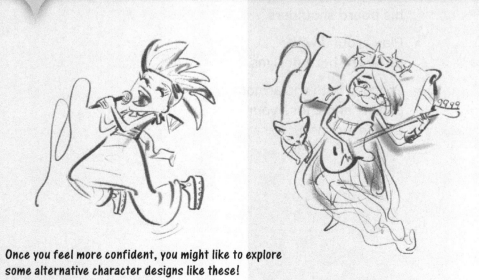

Once you feel more confident, you might like to explore some alternative character designs like these!

Robot knight

Complete the subject, drawing directly onto the page.

Beginners' challenge

» Armor plates cover the knight's body from head to toe – draw them as you like

» Follow with the sword and shield held by strong metal arms

» Decide on your knight's expression and go for it

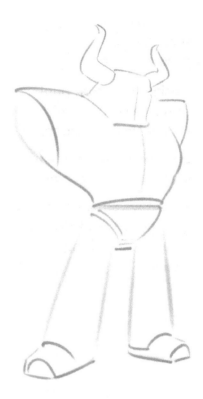

Next-level

» A small square-shaped head perches on top of his board shoulders

» Play around with different horn designs

» Proceed with the armor plating and chose your own weapons

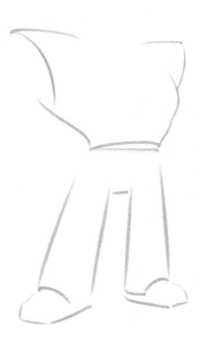

» Take the time to build your knight with different forms

» Make him an action figure and play with the angles of his pose

» Costume and weapon details can really give your robot knight a different look – have fun with it

Here's what to aim for with your finished drawings!

TIP · 3D FORM

Transforming 2D shapes into a 3D forms involves adding angles, curves, and shading. Observe the differences between the shapes above. Imagine there's a light source coming from the top left of the object and start shading on the opposite side. Start lightly and follow the direction of the form for greatest effect.

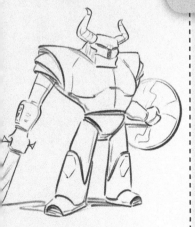

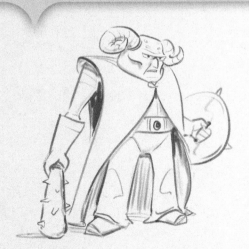

Once you feel more confident, you might like to explore some alternative character designs like these!

Sorcerer

Complete the subject, drawing directly onto the page.

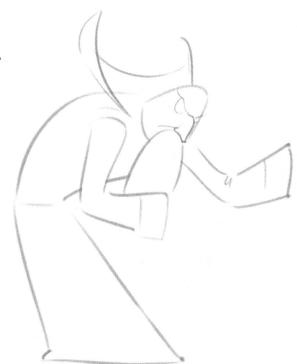

Beginners' challenge

» Draw the sorcerer's boney hands, one in a grip position and the other open and facing upwards

» The staff can be designed by you – be it ancient or modern in shape, bejeweled or less decorative

» Work up his facial features to give him a truly evil look

Next-level

» With the face cross already in place, start drawing in his furrowed brow and long hooked nose

» Have fun with his long flowing beard and mustache – he is an entertainer, after all

» Arms are drawn bent at an angle and are dressed with flared decorative sleeves

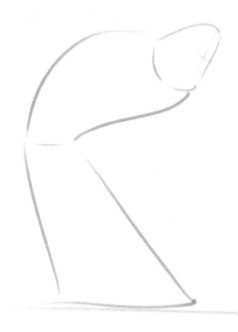

» His hunch is set up but from there you can start playing with your own design

» What if our sorcerer was working in a lab or looking into a crystal ball?

» Add props and costume to modernize or suggest a different background

Here's what to aim for with your finished drawings!

TIP · HAND GESTURES

Without something to hold onto, hands can still be very expressive. Notice how expressive the hands of the sorcerer are as he is concocting his potion or summoning the future via his crystal ball. Experiment with different hand gestures to complement your character's actions.

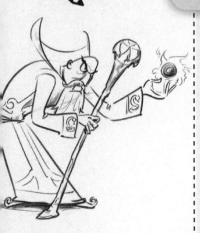

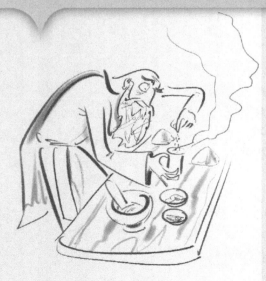

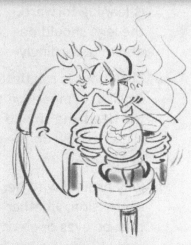

Once you feel more confident, you might like to explore some alternative character designs like these!

Unicorn

Complete the subject, drawing directly onto the page.

Beginners' challenge

» Our unicorn is a dancer and prancer who likes to show off, so draw her mane and tail with lots of flowing curves

» A happy expression follows, with upturned mouth and flared nostrils – don't forget the horn

» Strengthen your line work and draw the cliff edge and moon to finalize your drawing

Next-level

» As our young unicorn is leaning forward, the legs should be drawn accordingly

» The snout is relatively small in comparison to the head and should be sketched low on the oval of the head

» Play around with her expression, whether that be eyes open or closed – have a say in how she looks

Creative blast-off

» Maybe you'd like your unicorn to be running through a field of flowers or saying "hi" to a dear friend – time to design her the way you want

» A new hairstyle? Why not!

» Place your new character in an environment of your choice, be it forest or open field

Here's what to aim for with your finished drawings!

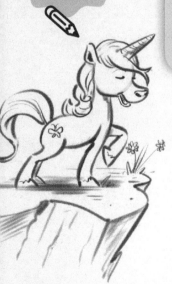

TIP · HAIR

Drawing hair requires a smooth touch and a great deal of practice. With a heavy hand it can turn your rendition of a horse or unicorn into a wiry mess. The first step is to articulate what direction the hair or fur is going. Use either long flowing lines or short connected curves to get the effect you want. As hair is rarely uniform in design, play around with overlapping shapes.

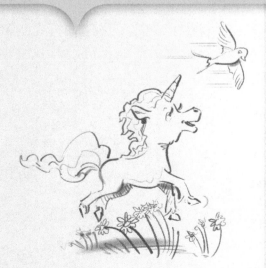

Once you feel more confident, you might like to explore some alternative character designs like these!

Warrior princess

Complete the subject, drawing directly onto the page.

Beginners' challenge

» The action pose is set – time to start drawing in the warrior's costume and facial features

» Flowing hair to follow created with flame-like shapes

» Arrows, boots, and other costume details will round off the drawing nicely

Next-level

» The forearms that you draw next almost form a straight line through the arrow

» Spend time with the expression to get her focused look just right – observe the eyebrows and slightly open mouth

» The full leather body outfit can be reimagined if you like – what about a cape or a large wrap-around belt?

76

» Time to design your action superstar from scratch – a flying kick could be the go or even swinging on a vine

» Bring the environment more into the picture by including trees or flames

» Create a villain and have her dueling with them – a battle royal indeed

Here's what to aim for with your finished drawings!

TIP · ACTION POSES

Action, action, action! The world is full of action superstars in the fields of sports, movies, and fantasy. These athletic heroines move with speed and grace, and contort their bodies in unusual ways. For the figure to be dynamic yet balanced, it's really important to spend time setting up the pose with strong underpinning action lines. Meanwhile, the warrior princess flying through the air has been almost turned into a human dart, with her arms and legs at dramatic angles and the lines through her hips and shoulders not horizontal. This is called a dynamic pose.

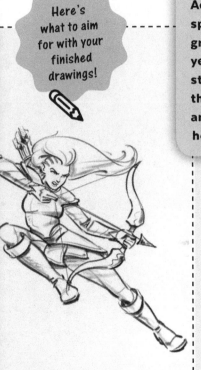

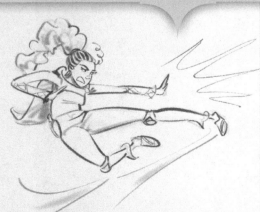

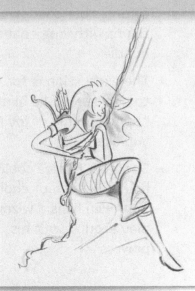

Once you feel more confident, you might like to explore some alternative character designs like these!

Wizard

Complete the subject, drawing directly onto the page.

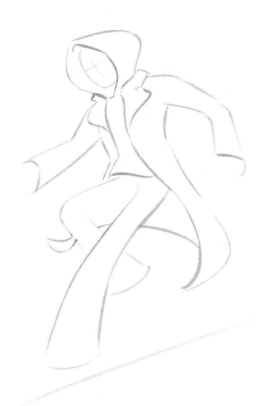

Beginners' challenge

» Start with the floppy fringe and serious facial expression before moving on to the hands

» Magical staff and bag can be of your own design – have fun with it

» Strengthen your line work and add a bit of shading to finalize your drawing

Next-level

» The form of the body is laid out, so now it's time to dress our shadowy figure with long coat and hoodie

» The expression is for you to decide – make him happy and full of joy if you like

» Shooting flames could be his weapon of choice but given he is a wizard, play around with his powers

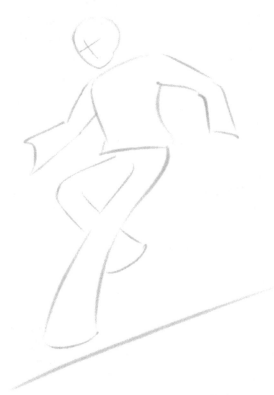

78

» If you'd like to have your wizard flying through the air, now is the time to do it – flying, leaping, running, it's your choice

» Under attack or in danger, enjoy placing your character in a brand-new environment

» Do away with the hoodie and the staff – a modern wizard can come in all sorts of guises

Here's what to aim for with your finished drawings!

TIP · PENCIL PRESSURE

Light pencil pressure is important when you begin a drawing, so you can erase if you make an error. Use this light pressure when indicating your underlying forms and through-lines. Once they're in place, you can build up the darkness of the pencil line and embellish with shading. As always - practice makes perfect.

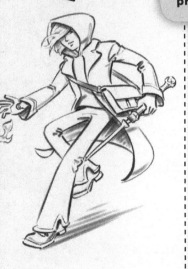

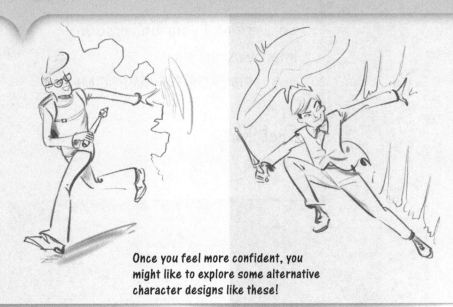

Once you feel more confident, you might like to explore some alternative character designs like these!

A JOB WELL DONE!

I hope you've enjoyed visiting **Planet Draw**. It's been a pleasure getting you started on your drawing adventure.

If you have any suggestions of what you'd like to see in the future, let me know via my website: **planetdraw.com**. I'd love to hear from you!

AND PLEASE ... **leave a review** if you liked 👍 or loved ♥ this title. Your feedback helps me to continue doing what I do – inspiring a new generation of budding artists with my drawing books.

So ... expand your universe ...
improve your skills ...
and UPGRADE TO AWESOME!

Paul Konye

Made in the USA
Columbia, SC
26 September 2019